Illustrazione della copertina "The New Yorker" / Giugno 1993 / cm. 20x28

"The New Yorker" cover illustration / June 1993 / cm. 20x28

Illustrazione per Aperol / 1988 / cm. 35x50

Illustration for Aperol / 1988 / cm. 35x50

Illustrazione tratta da "Eugenio" con Marianne Cockenpot / Editions Du Seuil / Francia Ottobre 1993 / cm. 34x24

Illustration from "Eugenio" with Marianne Cockenpot / Editions Du Seuil, FRANCE / October 1993 / cm. 34x24

Illustrazione libro "Il Padiglione Sulle Dune" di R.L. Stevenson / Edizioni Nuages / Novembre 1992

Illustration for "The Pavillon On The Dunes" by R.L. Stevenson / Edizioni Nuages / November 1992

Illustrazione per rivista "Vanity" / Ottobre 1989 / Condé Nast cm. 22x28

Illustration for "Vanity" magazine / October 1989 / Condé Nast / cm. 22x28

Illustrazione "I Fiori del bene" / Edizioni Nuages / 1994 / cm. 25x35

Illustration Entitled "The Flowers of Good " / Edizioni Nuages / 1994 / cm. 25x35

MEMBRI DELLA COMMISSIONE
INTERNAZIONALE
DI SELEZIONE 1994

MEMBERS OF THE 1994
INTERNATIONAL SELECTION
COMMITTEE

1 **Anne Baronian**
Rainbow Grafics
International
Brussels, Belgium

2 **Ute Blaich**
Rowohlt Taschenbunch Verlag
Reinbek, Germany

3 **Stephen Roxburgh**
Farrar, Straus & Giroux
New York, USA

«Siamo molto grati all'Ente Fiere di averci invitato a selezionare gli artisti per la Mostra Illustratori 1994. Abbiamo accettato questo impegno con la coscienza di rappresentare l'intera comunità editoriale, ma consapevoli, al tempo stesso, della nostra individuale formazione culturale.
Abbiamo volutamente cercato di accogliere tradizioni figurative che ci erano poco familiari e, quando abbiamo avuto dei dubbi, abbiamo preferito correre il rischio di sbagliare ammettendo, piuttosto che escludendo.
Siamo stati lieti di scoprire che in questi tempi di difficoltà economiche generalizzate, esiste, nonostante tutto, una grande ricchezza di talenti artistici.
Il campo delle proposte era ampio, senza limitazioni geografiche, di nazionalità, età o razza.
La partecipazione è stata ampiamente incoraggiata e la risposta senza precedenti; più di 1400 artisti hanno, infatti, inviato le proprie opere.
La selezione si è basata su tre criteri: abbiamo valutato le qualità professionali della presentazione come indice del rispetto degli artisti per il proprio lavoro e per il pubblico; abbiamo privilegiato la comprensibilità e accessibilità delle opere più che l'astrazione e la componente decorativa; abbiamo scelto artisti i cui lavori ci hanno toccato vuoi per l'intelligenza o lo humour, il sentimento o il fascino, la sincerità o l'inventiva.
Infine, abbiamo cercato, e trovato in abbondanza, immagini suggestive che rimangono impresse a lungo.
La Mostra rappresenta il meglio di ciò che abbiamo visto, cosa che non significa, naturalmente, il meglio possibile. E' soltanto, e lo crediamo sinceramente, un inizio. Raccomandiamo ai nostri colleghi editori di andare alla scoperta di quegli artisti che ancora non conoscono ed esortiamo gli artisti - sia quelli che espongono in questa Mostra sia quelli che la visiteranno - a chiedere il consiglio degli editors e degli art directors. Ognuno di loro ha molto da offrire agli altri e saranno i ragazzi di tutto il mondo i beneficiari di questa collaborazione.»

"We are grateful to the Fiera di Bologna for inviting us to select the artists for the Exhibition. We came to the task conscious of our expanded roles as representatives of the global publishing community, and also aware of our individual cultural biases. We deliberately attempted to accomodate traditions that we were unfamiliar with, and when we were in doubt, chose to err by inclusion rather than exclusion. We were delighted to discover that in these times of universal economic difficulties, there is nevertheless a great wealth of artistic talent.
The field of submissions was vast, unrestricted by geography, nationality, age or race. Participation was widely encouraged and the response was unprecedented. Over 1400 artists sent in their work. As we made our selections, three assumptions emerged. We were drawn to professional quality of presentation reflecting the artists' respect for their work and the audience. We preferred readability and accessibility over abstraction and decoration. We chose artists whose work moved us, either through wit or humor, sentiment or charm, truthfulness or invention. Ultimately, we looked for and found, in abundance, compelling and memorable images.
The exhibition represents the best of what we saw, which is not to say the best that is possible. It is, we sincerely believe, only a beginning. We encourage our fellow publishers to seek out the artists - whose work they do not know and we encourage artists those exhibited here and those viewing these works - to seek the guidance of editors and art directors. Each has much to offer the other. The children of the world will be the beneficiaries."

"Gli Illustratori dell'Anno"
Premio UNICEF - Fiera del Libro per
Ragazzi di Bologna

"Illustrators of the Year Award"
UNICEF - Bologna Book Fair

Tra gli artisti selezionati per la partecipazione alla Mostra degli Illustratori 1994, una giuria di esperti dell'UNICEF ha scelto i vincitori del Premio internazionale 1994 "Gli Illustratori dell'Anno".

Nato in collaborazione tra la Fiera del Libro e l'UNICEF, questo Premio giunto alla sua terza edizione, ha designato 10 artisti di varia nazionalità ai quali verrà affidato il compito di illustrare le cartoline augurali per il 50mo anniversario dell'UNICEF, nel 1996.

Gli artisti prescelti sono:
François Crozat, *Francia*
Jacqueline Fortin, *Canada*
Koen Fossey, *Belgio*
Claudio Gardenghi, *Italia*
Iassen Ghiuselev, *Bulgaria*
Bob Graham, *Australia*
Loek Koopmans, *Olanda*
Don Sullivan, *USA*
Jutta Timm, *Germania*
Ulises Wensell, *Spagna*

A jury of experts from UNICEF has selected the winners of the International "Illustrators of the Year" 1994 Award from among the artists admitted to the 1994 Illustrators Exhibition.

A joint initiative by the Book Fair and UNICEF, this award, now in its third year, focuses on 10 artists of different nationalities who will be commissioned to illustrate the greetings cards marking UNICEF'S 50th Anniversary, in 1996.

The selected artists are:
François Crozat, France
Jacqueline Fortin, Canada
Koen Fossey, Belgium
Claudio Gardenghi, Italy
Iassen Ghiuselev, Bulgaria
Bob Graham, Australia
Loek Koopmans, The Netherlands
Don Sullivan, USA
Jutta Timm, Germany
Ulises Wensell, Spain

ILLUSTRATORI SELEZIONATI
SELECTED ILLUSTRATORS

14 **A**cocella Paola
16 Andrikopoulos Nicholas
18 **B**arankova Vlasta
20 Batigne Laurence
22 Battaglia Maria
24 Boiry-Cau Veronique
26 Braun Mathias
28 Briswalter Maren
30 Brunswick Cecile
32 **C**echová Klára
34 Chatellard Isabelle Anne
36 Chica
38 Chieux Benoit
40 Chmielewski Gerald
42 Crozat François
44 **D**'Ottavi Francesca
46 De Paoli Gaia
48 Deru Myriam
50 Di Martino Emmanuelle
52 **E**nsikat Klaus
54 Evangelista Mauro
56 **F**iocchi Giona
58 Forestier Isabelle
60 Fortin Jacqueline
62 Fossey Koen
64 Neves França Eliardo
66 **G**ardenghi Claudio
68 Gasser Maria Luisa
70 Gaudasiriska Elzbieta
72 Gepner Sacha
74 Ghiuselev Iassen
76 Giovanelli Maria Giorgia

78 Graham Bob
80 Graham Mark
82 Guan Weixing
84 **H**ewitt Kathryn
86 **J**erome A. Karen
88 **K**asparavičius Kęstutis
90 Kazdailyte Agné
92 Kiuchi Tatsuro
94 Koopmans Loek
96 Kubbos Alíson
98 **L**ausche Katharina
100 Lemaître Pascal
102 **M**arks Alan
104 Menon Emanuela
106 Montenovesi Luca
108 Müller Thomas
110 Müller Thomas Matthaeus
112 **N**aujok Corinna
114 Nikan Pour Abkar
116 Nine Carlos

118 Nomura Naoko
120 **O**blucki Janusz
122 Olivotto Maurizio
124 Orlandini Maria Grazia
126 **P**acovská Květa
128 Pla Santamans Imma
130 Prachatická Markéta
132 **R**anta Maija
134 Rényi Krisztina
136 Riha Susanne
138 Rinaldi Cristina
140 Rowe John
142 **S**acré Marie-José
144 Sagasti Miriam
146 Saks Reti
148 Speck Kafkoulas Beate
150 Sullivan Don
152 **T**akáts Márton
154 Timm Jutta
156 Törnqvist Marit
158 Trentini Monia
160 **U**rquijo Clara
162 **V**alderrama Rosario
164 Venturini Claudia
166 **W**ang Chia-Chu
168 Wensell Ulises
170 Wilkón Józéf
172 **Z**eman Ludmila
174 Zwerger Lisbeth

ANNUAL 94

PAOLA ACOCELLA

Address
Via Puccini 18
80127 Napoli
(Italy)

Place and date of birth
Naples,
20 January 1970

Art School attended
European College of Design,
Rome

Title of the work
The Level

Technique
Coloured pencils and chalks

Legend
The other one, behind him, was shabby and carried a broom

"Don't you understand that in here we are all alike? You are dead and so am I; we are all the same".

NICHOLAS ANDRIKOPOULOS

Address
75 Cretas Street
14231 Athens
(Greece)

Place and date of birth
Athens,
9 December 1955

Art School attended
Centre of Technological
Applications (Graphic Designers
Course)

Title of the work
Children's Dreams

Technique
Mixed

Legend
Dancing on the moon

All things come to an end

The dream begins

VLASTA BARANKOVA

Address
c/o Bohem Press
Gerechtigkeitsgasse 31
8002 Zürich
(Switzerland)

Place and date of birth
Brno,
1943

Art School attended
Academy of Fine Arts, Brno

Works published by
Bohem Press, Zurich
Edizioni Arka, Milano
Editions Epigones, Paris
Gooi & Sticht, Hilversum
Lasten Keskus, Helsinki
Sagostunen, Göteborg

Title of the work
Bim, Bam, Bum

Original Publisher and date date of publication
Bohem Press,
Zurich 1994

Technique
Mixed

Legend
In the Gallery

Tea Time

LAURENCE BATIGNE

Address
9 bis rue de Zürich
67000 Strasbourg
(France)

Place and date of birth
Strasbourg,
22 September 1958

Art School attended
School of Decorative Art,
Strasbourg

Works published by
Casterman S.A. Editeurs,
Tournai
Editions Fernand Nathan, Paris
Lito Editions, Champigny sur
Marne
Rouge et Or, Paris

Title of the work
Goldilocks and the Three Bears

Original Publisher and date of publication
Lito Editions,
Champigny sur Marne, 1992

Technique
Ecoline, brush

Legend
Goldilocks falls asleep in Baby Bear's bed

"Who's been sitting on my chair?" cried Daddy Bear

MARIA BATTAGLIA

Address
Piazzetta Conti Guerra 19
12042 Bra/Cuneo
(Italy)

Place and date of birth
Mondovì,
26 October 1963

Art School attended
European College of Design,
Milan

Works published by
Editions Syros/Alternatives,
Paris
Editions Ipomée, Moulins
Albin Michel Jeunesse, Paris
Grimm Press, Taipei

Title of the work
The Magic Castle

Original Publisher and date of publication
Grimm Press,
Taipei, August 1993

Technique
Coloured pencils, watercolour

Legend
The Magic Castle

VERONIQUE BOIRY-CAU

Address
6 rue Asselin
50100 Cherbourg
(France)

Place and date of birth
Toulon,
9 July 1948

Art School attended
School of Art, Paris

Works published by
Grasset Jeunesse, Paris
Bayard-Presse, Paris
Casterman S.A., Paris
Hachette, Paris
Editions Milan, Toulouse

Title of the work
The Frog King

Original Publisher and date of publication
Hachette,
Paris, 1993

Technique
Ink, watercolour and pastel crayons

Legend
It's a lucky day for you

Why are you frightened?

MATHIAS BRAUN

Address
25 Avenue de Paris
68000 Colmar
(France)

Place and date of birth
Colmar,
7 June 1971

Art School attended
School of Decorative Art,
Strasbourg

Title of the work
"Nachtschangi"

Technique
Coloured ink

Legend
He took the light and went to the window

The calf took him by the nose and blew so hard that he swelled up

Stuck there for two days and three nights, the whole town came to laugh at him

MAREN BRISWALTER

Address
Gesellgenstrasse 8
55578 Wallertheim
(Germany)

Place and date of birth
Elgersburg,
2 May 1961

Art School attended
Hochschule für Gestaltung
Offenbach

Works published by
Anrich Verlag GmbH, Kevelaer
Dressler Verlag, Hamburg
Ravensburger Buchverlag Otto
Maier GmbH, Ravensburg
Verlag Nagel & Kimche AG,
Zurich

Title of the work
"Haustikausti"

Original Publisher and date of publication
Anrich Verlag GmbH,
Kevelaer, February 1993

Technique
Airbrush, coloured pencils

Legend
Hanskarl lived with his aunt

Lucky Haustikausti

CECILE BRUNSWICK

Address
127 West 96th Street - 15D
10025 New York
(USA)

Place and date of birth
Antwerp,
1930

Art School attended
Parsons, Art Students League

Works published by
Pomegranate Art Books, Corte Madera, CA

Title of the work
Umbrellas

Technique
Pastel - coloured polaroid transfers

Legend
He sees a lot of umbrellas walking down the street

A red, yellow, green and blue umbrella shades the painter's picture

In the park a strolling umbrella looks like a red dot in a white field

The boy's umbrella keeps out the cold wind while he plays in the snow.

KLÁRA ČECHOVÁ

Address
Feldherrn Strasse 49
44147 Dortmund
(Germany)

Place and date of birth
Prague,
1 January 1963

Art School attended
Art Training College, Munich

Works published by
Patmos Verlag, Düsseldorf

Title of the work
The Princess Who Wouldn't Eat

Technique
Mixed

Legend
Meals were prepared throughout the country

Once upon a time there was a princess

ISABELLE ANNE CHATELLARD

Address
93 rue Tonchet
69006 Lyon
(France)

Place and date of birth
Sallanches,
24 January 1970

Art School attended
School Emile Cohl, Lyon

Works published by
Milan editions, Toulouse
Gallimard Jeunesse, Paris
Editions Fleurus, Paris
La Farandole/Messidor, Paris

Title of the work
Ermeline the Enchantress and the Chaffinch

Technique
Acrylic

Legend
The chaffinch found Ermeline the enchantress

The threat

The magic formula before the metamorphosis

CHICA

Address
8 rue Jules Chaplain
75006 Paris
(France)

Place and date of birth
Paris,
29 May 1933

Art School attended
Art School, Paris

Works published by
Hachette, Paris
Gautier-Languerau, Paris
Editions Fernand Nathan, Paris
Editions Syros/Alternatives, Paris
La Farandole/Messidor, Paris
Editions Magnard, Paris
Flammarion - Père Castor, Paris
Editions Rouge et Or, Paris

Title of the work
How Giants Dress

Technique
Coloured ink

Legend
Mountain coat and three piece suit

The thunder-protection hat

BENOIT CHIEUX

Address
La Guillouiere Route de Voiron
38430 Moirans
(France)

Place and date of birth
Lille,
13 October 1960

Art School attended
School Emile Cohl, Lyon

Works published by
Grimm Press, Taipei

Title of the work
The Happy Prince

Original Publisher and date of publication
Grimm Press,
Taipei, January 1994

Technique
Watercolour

Legend
A swallow flew through the forest when the sun went down

GERALD CHMIELEWSKI

Address
Doodshörnerweg 23
26316 Varel
(Germany)

Place and date of birth
Varel,
24 December 1958

Art School attended
Fachhochschule für Grafik und Design, Münster

Works published by
Esslinger Verlag, Esslingen
Verlag J.F. Schreiber GmbH, Esslingen

Title of the work
Ten Dresses for Mantombi

Original Publisher and date of publication
Verlag J.F. Schreiber GmbH, Esslingen, 1993

Technique
Airbrush and coloured pencils

Legend
Mantombi and her friends go to the police

Mantombi and her mother live in a shanty-town on the outskirts of Cape Town

FRANÇOIS CROZAT

Address
Denfert Rochereau 8
69700 Givors
(France)

Place and date of birth
Givors,
24 November 1928

Art School attended
School of Fine Arts, Lyon

Works published by
Albin Michel Jeunesse, Paris
Barron's Educational Series,
Inc., Hauppauge N.Y.
Gakken Co. Ltd., Tokyo
Editions Milan, Toulouse
Verlag J.F. Schreiber GmbH,
Esslingen
Creative Education, Inc.,
Mancato MN

Title of the work
The Intrepid Baptist

Technique
Gouache

WINNER OF THE 94 ILLUSTRATORS
OF THE YEAR AWARD
UNICEF / BOLOGNA BOOK FAIR

FRANCESCA D'OTTAVI

Address
Via Tommaso Fortifiocca 114
00179 Roma
(Italy)

Place and date of birth
Rome,
30 January 1969

Art School attended
European College of Design

Works published by
Curcio Armando Editore, Rome
Ilex Publishers Ltd., Oxford
Dorling Kindersley Children's,
London

Title of the work
Little Red Riding Hood

Technique
China ink, acrylic

Legend
Everyone adored her, and especially her grandmother who gave her a red velvet riding hood

When he entered the wood she met the wolf but she was not afraid

"How the old lady snores! I must have a look!"

GAIA DE PAOLI

Address
Piazza Grandi 3
20129 Milano
(Italy)

Place and date of birth
La Spezia,
31 January 1964

Art School attended
European College of Design,
Milan

Title of the work
Biancorì the Filly

Technique
China ink, watercolour, coloured pencils

Legend
Lappo the bear recited Shakespeare as he washed

But Biancorì went away every Wednesday

MYRIAM DERU

Address
75 rue du Tilleul
1332 Genval
(Belgium)

Place and date of birth
Libenge,
23 November 1954

Art School attended
St. Luc College of Graphic Art,
Brussels

Works published by
Gautier-Languereau, Paris
Casterman S.A. Editeurs,
Tournai
Editions Lito, Champigny sur
Marne

Title of the work
Charlie Likes Sports

Original Publisher and date of publication
Gautier-Languereau,
Paris, 1993

Technique
Watercolour, coloured pencils, pen

Legend
Charlie lifting weights

Charlie does judo

Charlie relaxes

EMMANUELLE DI MARTINO

Address
"Les Vallées"
167 rue Aimé Dennel
60280 Margny les Compiegne
(France)

Place and date of birth
Salon de Provence,
11 December 1968

Art School attended
School of Decorative Art

Works published by
Eiselé S.A., Prilly

Title of the work
Paco, Modern Day Traveller

Legend
He even travels on a carpet, in a ballon and in a life-buoy

KLAUS ENSIKAT

Address
Anton Saefkow Platz 14
10369 Berlin
(Germany)

Place and date of birth
Berlin,
16 January 1937

Art School attended
Institute of Applied Arts, Berlin

Works published by
Rowohlt Taschenbuch Verlag
GmbH, Reinbek

Original Publisher and date of publication
Rowohlt Taschenbuch Verlag
GmbH,
Reinbek, November 1993

Technique
Ink

Legend
Alice had never seen a rabbit wearing a waistcoat before

"Oh Mouse, can you tell me how to get out of this pond?"

Marzolina the Hare and the Mad Hatter were sitting at the table drinking tea

MAURO EVANGELISTA

Address
c/o Da Vergini 18
62100 Macerata
(Italy)

Place and date of birth
Macerata,
21 October 1963

Art Schools attended
Art College, Macerata
Academy of Fine Arts,
Venice/Macerata
Oland Grafinska Skola, Svezia

Title of the work
At the Country Fair

Technique
Watercolour, china ink, pastel

Legend
The travelling barrel-organ

The human cannonballs

54

The Rocket Men

GIONA FIOCCHI

Address
Via Montello 34
21100 Varese
(Italy)

Place and date of birth
Varese,
6 June 1969

Art Schools attended
Art School, Milan
Academy of Fine Arts, Milan
Academy of Fine Arts, Vienna
Hochschule für Angewandte Kunst, Vienna

Title of the work
The Story of the Hazel

Technique
Raxed copies on polyester from pencil and ink originals

Legend
The Hazel bird

The road that leads to the villa at Neveklosterburg

The villa and the library

ISABELLE FORESTIER

Address
3 rue de Grenelie
75006 Paris
(France)

Place and date of birth
Paris,
15 December 1954

Art Schools attended
Academy of Fine Arts, Anecy
Academy of Fine Arts,
Perdignau

Works published by
Grimm Press, Taipei

Title of the work
Leo and Merio

Publisher and date of publication
Grimm Press,
Taipei, January 1994

Technique
Watercolour

Legend
The crane met the princess in the garden

The crane turns into a frog to rescue the princess

JACQUELINE FORTIN

Address
6-91 Gérard Morisset
Québec City, Qc G1S 4V5
(Canada)

Place and date of birth
20 June 1952

Art School attended
Laval University, ,Québec

Title of the work
Complexion Complex

Technique
Coloured pencils

Legend
The jaguar is envious of the giraffe's great spots

The tiger is envious of the zebra's decorative stripes

WINNER OF THE 94 ILLUSTRATORS OF THE YEAR AWARD
UNICEF / BOLOGNA BOOK FAIR

KOEN FOSSEY

Address
Heuven 35 a
3520 Zonhoven
(Belgium)

Place and date of birth
Anderlecht, 30 June 1953

Art School attended
Royal Academy of Fine Arts, Antwerp

Works published by
Clavis, Hasselt
Albert Whitman & Company, Morton Grove IL
Hachette, Paris

Title of the work
A Tale of Two Tengu

Original Publisher and date of publication
Albert Whitman & Company, Morton Grove IL, 1993

Technique
Pen, acrylic paint

Legend
Joji's nose grew long, long, longer.

Lord Nakamura eased one hand out of his kimino sleeve and reached for the long blue nose

"Look", cried Princess Fumiko. "That's the blue pole that stole my kiminos!"

Kenji and Joji were proud of their extraordinary noses.

WINNER OF THE 94 ILLUSTRATORS OF THE YEAR AWARD
UNICEF / BOLOGNA BOOK FAIR

ELIARDO NEVES FRANÇA

Address
Rua Rocha 268/22
01330.000 São Paulo
(Brazil)

Place and date of birth
Santos Dumont, Minas Gerais,
17 June 1941

Works published by
Editora Ática, São Paulo

Title of the work
H.C. Andersen Tales and A Beautiful Smile

Original Publisher and date of publication
Editora Ática,
São Paulo, 1992

Technique
Watercolour and wax crayon

Legend
*"I want to have a small child",
she told the old whitch*

*"But he isn't wearing any
clothes!" cried a child*

CLAUDIO GARDENGHI

Address
Viale Krasnodar 138
44100 Ferrara
(Italy)

Place and date of birth
Poggio Renatico,
7 July 1949

Art Schools attended
School of Art, Ferrara
Academy of Fine Arts, Bologna

Works published by
Arnoldo Mondadori Editore, Milan
Verlag J.F. Schreiber GmbH, Esslingen

Title of the work
Desolina

Technique
Pencil, coloured pencils

Legend
Dolfo

Desolina and Elisabetta are chatting

Zanilla

WINNER OF THE 94 ILLUSTRATORS OF THE YEAR AWARD
UNICEF / BOLOGNA BOOK FAIR

MARIA LUISA GASSER

Address
Via Mantele 1
39010 Nalles/Bolzano
(Italy)

Place and date of birth
Bolzano,
14 February 1961

Art School attended
Art College, Urbino

Title of the work
Nils Holgersson's Wonderful
Journey With the Wild Geese

Technique
Coloured pencils

Legend
If Martin the goose had not brought food to the gosling lying
wounded on the stones, she would certainly have died of starvation

The next day the wild geese flew north

ELIZBIETA GAUDASIRISKA

Address
05-070 Sulejowek 15
Broniewskiego
(Poland)

Place and date of birth
Strzyzow,
27 January 1943

Art School attended
Academy of Fine Arts, Warsaw

Works published by
Grimm Press, Taipei

Title of the work
Beauty and the Beast

Original Publisher and date of publication
Grimm Press,
Taipei, January 1994

Technique
Watercolour

Legend
The beast was trapped by the hunters

Beauty lived in a small hut

SACHA GEPNER

Address
66 rue de Crimée
75019 Paris
(France)

Place and date of birth
Metz,
3 February 1926

Art School attended
National High School of Applied Arts

Works published by
Editions Hatier, Paris

Title of the work
The Adventures of Sherlock Holmes

Original Publisher and date of publication
Editions Hatier,
Paris, December 1993

Technique
Ink, watercolours

Legend
Sherlock Holmes spent the night smoking

The steps led to the opium den

IASSEN GHIUSELEV

Address
Christo Smirnenski 38
1164 Sofia
(Bulgaria)

Place and date of birth
Sofia,
24 July 1964

Art School attended
Academy of Fine Arts, Sofia

Works published by
La Nuova Italia Editrice,
Florence
Giunti Gruppo Editoriale,
Florence
Lo Scarabeo, Turin
Ideogramma, Turin

Title of the work
The Adventures of Pinocchio

Publisher and date of publication
Ideogramma
Turin, 1994

Technique
Tempera

Legend
Mangiafuoco sneezes and forgives Pinocchio, who then saves his friend Arlecchino

The Lobster Inn

Instead of turning into a boy, Pinocchio leaves secretly with his friend Lucignolo for Toyland

The director of a clown company buys him in order to teach him to dance and skip

WINNER OF THE 94 ILLUSTRATORS
OF THE YEAR AWARD
UNICEF / BOLOGNA BOOK FAIR

MARIA GIORGIA GIOVANELLI

Address
Via Carducci 10
61038 Orciano di Pesaro
(Italy)

Place and date of birth
Fano,
10 August 1966

Title of the work
Animal Alphabet

Technique
Coloured pencils

Legend
Giraffe

Rooster

BOB GRAHAM

Address
19 Plant Street
3070 Northcote, Victoria
(Australia)

Place and date of birth
Sydney,
20 October 1942

Art School attended
Julian Ashton Art school,
Sydney

Works published by
Lothian Books, Melbourne
Walker Books Ltd., London
Bayard-Presse, Paris

Title of the work
Spirit of Hope

Publisher and date of publication
Lothian Books,
Melbourne, 1993

Technique
Coloured pencils, inks and pastels

Legend
Dad washed off the oil from the factory. Mum sang and Dad did his bird calls. A chair was put on the kitchen table.

"What is the name of your ship?" Dad called
"Spirit of Hope", the sailors shouted

WINNER OF THE 94 ILLUSTRATORS
OF THE YEAR AWARD
UNICEF / BOLOGNA BOOK FAIR

願望號

MARK GRAHAM

Address
19 Hilltop Road
11050 Port Washington NJ
(USA)

Place and date of birth
Salt Lake City,
3 February 1952

Art School attended
Art Students League of New York

Works published by
Morrow Junior Books, New York
McElderry Books, New York
Simon & Schuster, New York

Title of the work
Where's the Baby

Original Publisher and date of publication
Morrow Junior Books,
New York, 1993

Technique
Oil paint on paper

Legend
Baby building with soup cans

Baby wrapped in towel

Baby reading story to stuffed animals

WEIXING GUAN

Address
c/o Grimm Press
12 F, No.447, Sec.4, Jen-Ai Rd
Taipei
(China)

Place and date of birth
Ji-Lin,
1940

Art School attended
Lu-Shiun Art Academy

Works published by
Grimm Press, Taipei

Title of the work
Life in the South of the Old Town

Original Publisher and date of publication
Grimm Press,
Taipei, January 1994

Technique
Watercolour

Legend
The street peddlar and the children

The street musician and the actress

On a cart

KATHRYN HEWITT

Address
2004 Ocean Park Boulevard, Ap. B
90405 Santa Monica CA
(USA)

Place and date of birth
Santa Monica,
24 May 1951

Art Schools attended
Cornish Art Institute, Seattle
Santa Monica College, California
Otis College of Art & Design, Los Angeles

Works published by
Hartcourt Brace & Company, San Diego

Title of the work
Lives of the Musicians: Good Times, Bad Times and What the Neighbours Thought

Original Publisher and date of publication
Hartcourt Brace & Company, San Diego, 1993

Technique
Watercolour

Legend
Igor Stravinsky

George Gershwin

KAREN A. JEROME

Address
56 Pickering Street
02192 Needham MA
(USA)

Place and date of birth
Norwood,
21 January 1959

Art School attended
Parsons School of Design, New York

Works published by
Scholastic Inc., New York

Title of the work
Teeth Week

Original Publisher and date of publication
Scholastic Inc.,
New York, 1993

Technique
Pen ink, watercolour, coloured pencils

Legend
She is afraid to stop and pick the markers up for the boys might make fun of her

Broderick races after Liza after she drops her markers. She is afraid that all he wants is to make fun of her

KĘSTUTIS KASPARAVIČIUS

Address
Gabijos 73-17
2022 Vilnius
(Lithuania)

Place and date of birth
Trakai,
2 June 1954

Art Schools attended
M.K. Ciurlionis Art School
Vilnius Art Academy

88

Works published by
Sviesa, Kaunas
Vyturis, Vilnius
Eesti
Raamat, Tallinn
Verlag J.F. Schreiber GmbH,
Esslingen
F. Coppenrath Verlag, Münster
Der Kinderbuchverlag, Berlin

Title of the work
Pinocchio

Original Publisher and date of publication
F. Coppenrath Verlag,
Münster, 1993

Technique
Watercolour

Legend
Pinocchio is born

The donkey Pinocchio at the circus

The director of the puppet theatre

AGNÉ KAZDAILYTÉ

Address
Tilto Street, 35/4-23
Vilnius
(Lithuania)

Place and date of birth
Vilnius,
27 December 1963

Art Schools attended
M.K. Ciurlionis Art School,
Vilnius
State Institute of Art, Vilnius

Works published by
Grimm Press, Taipei

Title of the work
The Bluebeard

Original Publisher and date of publication
Grimm Press,
Taipei, January 1994

Technique
Watercolour

Legend
Bluebeard lives alone in his little hut

The magician died suddenly

TATSURO KIUCHI

Address
3-26-20 Takanodai
Nerimaku
Tokyo 177
(Japan)

Place and date of birth
Tokyo,
2 February 1966

Art School attended
Art Center College of Design,
USA

Works published by
Harcourt Brace & Company, San Diego CA

Title of the work
The Lotus Seed

Original Publisher and date of publication
Harcourt Brace & Company, San Diego CA

Technique
Oil on paper

Legend
One day bombs fell around

I wrapped my seed and hid it

One night he stole the seed and planted it somewhere

LOEK KOOPMANS

Address
Grotekreek 21
8032 JD Zwolle
(The Netherlands)

Place and date of birth
Haarlem,
16 May 1943

Art School attended
School of Fine Arts, Arnhem

Works published by
Mangold Verlag LDV
Datenverarbeitung Gesellschaft
GmbH, Graz

Title of the work
Fairy Tale in Summerwood

Original Publisher and date of publication
Mangold Verlag LDV
Datenverarbeitung Gesellschaft
GmbH,
Graz, January 1993

Technique
Watercolour

Legend
Making Plans....

and five.... and then.....

WINNER OF THE 94 ILLUSTRATORS
OF THE YEAR AWARD
UNICEF / BOLOGNA BOOK FAIR

ALISON KUBBOS

Address
131 Bedford Street
Newtown 2042
(Australia)

Place and date of birth
Crow's Nest, Sydney,
28 March 1971

Art Schools attended
College of Fine Arts
University of New South Wales

Works published by
Random House Australia,
Milsons Point

Title of the work
The Seven Kids and Their Mother

Technique
Mixed media (graphite, coloured ink, black ink)

Legend
They opened the door, and the wolf rushed in and gobbled them up

There was once a nanny-goat who had seven little kids

KATHARINA LAUSCHE

Address
Schloss Strasse 88
60486 Frankfurt
(Germany)

Place and date of birth
Frankfurt,
31 December 1959

Art School attended
University Course on Figurative Arts

Works published by
Verlag an der Este, Buxtehunde
Rowohlt Taschenbuch Verlag GmbH, Reinbek

Original Publisher and date of publication
Rowohlt Taschenbuch Verlag GmbH,
Reinbek, September 1993

Technique
Coloured pencils

Legend
Flori the cat

The cat with his kitten

Cats' fighting

PASCAL LEMAITRE

Address
rue Campenhout 43
1050 Bruxelles
(Belgium)

Place and date of birth
Brussels,
6 February 1967

Art School attended
Ensau/Cambre Brussels

Works published by
Edition du Seuil Jeunesse, Paris
Hamish Hamilton Children's Books, London
Troll Associates, Mahwah NJ
Editions Averbode, Averbode

Title of the work
Cover of Dauphin magazine

Original Publisher and date of publication
Editions Averbode,
Averbode, 1993

Technique
Drawing and photo

Legend
The fox

Animal transport

ALAN MARKS

Address
Padbrook, Mill Lane
Elmstone Canterbury
(Great Britain)

Works published by
Michael Neugebauer Verlag, Zurich/Salzburg
North South Books, Inc., New York
Editions Nord-Süd, Paris
Jane Goodall Institute, Limington

Title of the work
With love

Original Publisher and date of publication
Jane Goodall Institute, Limington

Legend
Gremlin, Gazahead and Gimble

Mel, a young chimpanzee

Madam bee

MANUELA MENON

Address
Via Pieve di Cadore 6
37124 Verona
(Italy)

Place and date of birth
Verona,
31 August 1962

Art Schools attended
Art School, Verona
Academy of Fine Arts G.B.
Cignaroli, Verona

Title of the work
Discovering the Beauty of
Flowers

Technique
Pastels

Legend
Iris

Narcissus

Dandelion

LUCA MONTENOVESI

Address
Via Bomarzo 30
00191 Roma
(Italy)

Place and date of birth
Rome,
15 December 1964

Art Schools attended
Art School
European Institute of Design

Title of the work
The Voyage of Esperanta

Technique
Pastel

Legend
The centre of the ship. "His look pierced the unknown that lay before us"

The bridge. "I knew each man's story and each man knew mine".

Abandonment. "We left anchors and chains behind us....."

THOMAS MÜLLER

Address
Brauweg 8
37073 Göttingen
(Germany)

Place and date of birth
Döbeln,
3 August 1955

Art School attended
Academy of Graphic and Book Design, Leipzig

Works published by
Ellermann Heinrich KG Verlag GmbH & Co., Munich
Wolfgang Mann-Verlag GmbH, Berlin
Ravensburger Buchverlag Otto Maier GmbH, Ravensburg

Title of the work
Lucas in the Shadow Forest

Original Publisher and date of publication
Ravensburger Buchverlag Otto Maier GmbH,
Ravensburg, 1993

Technique
Watercolour, mixed media

Legend
Lucas with the shadow

The shadow man

THOMAS MATTHAEUS MÜLLER

Address
Oststrasse 8
D-07548 Gera
(Germany)

Place and date of birth
Gera,
26 September 1966

Art School attended
College of Graphic Design and
Illustration, Leipzig

Works published by
Elefanten Press Verlag GmbH,
Berlin
Volk und Wissen VEB, Berlin

Title of the work
Sixteen Fabulous Pages

Technique
Individually drawn on off-set
film, off-set printing

**Das Murmeltier,
das murmelt viel,
wir sehn es hier
beim Murmelspiel.**

*Der Philosoph,
der ist so doof,
daß er sich — knack,
brach das Gnack.*

CORINNA NAUJOK

Address
Ludwigkirchstrasse 9A
10719 Berlin
(Germany)

Place and date of birth
Berlin,
26 July 1957

Art School attended
Berlin Academy of Arts

Works published by
Wolfgang Mann- Verlag GmbH,
Berlin
Velber Verlag GmbH, Seelze

Title of the work
The Penguin Family

Original Publisher and date of publication
Wolfgang Mann-Verlag,
Berlin, December 1993

Technique
Watercolours, coloured pencils

Legend
Puck and the others on their way to the nesting place

The penguin family

AKBAR NIKAN POUR

Address
Khaled Eslamboli Ave.
15116 Tehran
(Iran)

Place and date of birth
Tehran,
4 June 1956

Art School attended
Faculty of Fine Arts
Tehran University

Works published by
Art & Literature Institute,
Tehran

Title of the work
First Flight

Legend
A young sparrow, while learning how to fly, crashes into a garden.
A boy keeps the sparrow

CARLOS NINE

Address
Juan de Garay 4268
1636 Olivos Buenos Aires
(Argentina)

Place and date of birth
Buenos Aires,
21 February 1944

Works published by
Editorial Sudamericana, Buenos Aires
Aique Grupo Editor S.A., Buenos Aires
Editori del Grifo, Montepulciano
Comic Art s.r.l., Rome
Albin Michel Jeunesse, Paris
Ikusager Ediciones, Victoria Alava

Title of the work
Irish Tales

Technique
Watercolours

Legend
The witch hare

The story of Conn-eda

NAOKO NOMURA

Address
3-17-9 Satsukino-nish
Mihava-chô, Minamikawachi-gun
587 Osaka
(Japan)

Place and date of birth
Nagoya,
26 May 1962

Art School attended
Seian Junior Art College, Kyoto

Title of the work
The Witch's Music Concert

Technique
Collage

Legend
Life was so utterly boring that the witch wanted something incredible to happen

The witch sends out invitations for the Christmas music concert

JANUSZ OBLUCKI

Address
Ul. Świętochowskiego 3 M 162
01-318 Warsaw
(Poland)

Place and date of birth
Wroclaw,
26 March 1956

Art School attended
Academy of Fine Arts, Warsaw

Works published by
Wydawnictwo Pik, Katowice

Title of the work
The Book of Poems

Original Publisher and date of publication
Wydawnictwo Pik,
Katowice, 1993

Technique
Tempera on paper

Legend
Birds rumours

The little buck

MAURIZIO OLIVOTTO

Address
Via Leonardo da Vinci 9
52024 Loro Ciuffenna / Arezzo
(Italy)

Place and date of birth
Bressanone,
2 March 1953

Art Schools attended
Art Institute of Urbino
Academy of Fine Arts, Florence

Works published by
Fatatrac, Florence
La Nuova Italia Editrice,
Scandicci

Title of the work
Time Alphabets

Technique
Etching and watercolour

Legend
The time of harmony

The time of fire

MARIA GRAZIA ORLANDINI

Address
Via Che Guevara 21
42100 Reggio Emilia
(Italy)

Place and date of birth
Reggio Emilia,
28 april 1968

Art School attended
Fine Arts Academy, Bologna

Works published by
Franco Panini Ragazzi, Ozzano Emilia

Title of the work
Alice in Wonderland

Original Publisher and date of publication
Franco Panini Ragazzi, Ozzano Emilia

Technique
China ink, watercolour, pastel

Legend
A white rabbit hurried past right in front of her

....... Alice saw the rabbit running ahead then suddenly he vanished as if into the air

The trial had already begun

KVĚTA PACOVSKÁ

Address
Nikoly Tesly 4/1092
16000 Praha 6
(Czechoslovakia)

Place and date of birth
Prague,
28 July 1928

Art School attended
Prague High School of Applied Arts

Works published by
Albatros, Prague
Neugebauer Press, Salzburg/Zurich
Ravensburger Buchverlag Otto Maier GmbH, Ravensburg
Verlag Beltz & Gelberg, Weinheim

Title of the work
Green Red All

Original Publisher and date of publication
Ravensburger Buchverlag Otto Maier GmbH, Ravensburg

Technique
Tempera, acrylic, pastel

IMMA PLA SANTAMANS

Address
Avd. Mistral 54. 4RT 1A
08015 Barcelona
(Spain)

Place and date of birth
Barcelona,
10 March 1964

Art School attended
Elisava Design School

Works published by
Ediciones Destino S.A.,
Barcelona
Publicacions de L'Abadia de
Montserrat, Barcelona
MSV

Title of the work
A Tale With No Sense

Original Publisher and date of publication
MSV,
December 1993

Technique
Watercolour

MARKÉTA PRACHATICKÁ

Address
Na Mícance 26
160 00 Prague 6
(Czech Republic)

Place and date of birth
Prague,
4 December 1953

Works published by
Albatross, Prague
Odeon, Prague
Viking, London
HarperCollins, London

Title of the work
James and the Giant Peach by Roald Dahl

Original Publisher and date of publication
HarperCollins,
London, 1991

Technique
Pen ink

Legend
Aunt Sponge was terrifically fat. Aunt Spiker was thin as a wire

Large fantastic faces peered down over the side of the peach

Aunt Sponge was like a great white soggy overboiled cabbage

MAIJA RANTA

Address
Kirstinsyrjä 7 A 21
02760 Espoo
(Finland)

Place and date of birth
Harjavalta,
20 October 1951

Art School attended
School of Advertising Graphics,
Helsinki

Works published by
Werner Söderström Osakeyhtyö
- WSYO, Helsinki

Title of the work
The Lost Pillow

Original Publisher and date of publication
Werner Söderström Osakeythiö -
WSOY,
April 1993

Technique
Watercolour and pencil

Legend
Visiting the church mouse

KRISZTINA RÉNYI

Address
Kålvariå 5
2000 Szentendre
(Hungary)

Place and date of birth
Budapest,
9 May 1956

Art School attended
Academy of Fine Arts

Works published by
Favorit Verlag, Rastatt
Gruppo Edicart, Legnano
Oy Kirjalito AB, Vantaa
Mora Ferenc, Budapest
Gulliver, Budapest
Editions Passage, Budapest
Europa, Budapest

Title of the work
The Christmas Secret

Original Publisher and date of publication
Favorit Verlag,
Rastatt, 1993

Technique
Watercolour, air brush, pen

Legend
Engelbert the rabbit hid under the Christmas trees on the truck

Winter arrives, a hard season for many animals

SUSANNE RIHA

Address
Hafnergasse 5
A-1020 Wien
(Austria)

Place and date of birth
Vienna,
18 June 1954

Art School attended
Institute of Graphic Art, Vienna

Works published by
Annette Betz Verlag, Vienna
Editions Milan, Toulouse
Almqvist & Wiksel Läromodel, Solna
Agertofts Forlag A/S, Copenhagen
Carolrhoda Books Inc., Minneapolis
Edizioni Piccoli, Turin
Verlag Carl Ueberreuter, Vienna

Title of the work
Guide to Birds

Original Publisher and date of publication
Carl Ueberreuter,
Vienna, 1993

Technique
Airbrush, gouache, pencil

Legend
In the forest

In the mountains

CRISTINA RINALDI

Address
Corso Garibaldi 70
20121 Milano
(Italy)

Place and date of birth
Milan,
19 January 1966

Art Schools attended
Academy of Fine Arts, Brera
Castello Sforzesco School of Illustration

Works published by
Arnoldo Mondadori Editore, Milan
Casa Editrice Principato, Milan
F.lli Fabbri Editori, Milan
Class Editori, Milan
Il Torchio Edizioni s.r.l., Milan

Title of the work
The Black Flamingo

Technique
Graphite pencil

Legend
Doctor Pagos tries out a new invention

Unaware of the black flamingo, the Duke Astolfo enters the secret laboratory

Doctor Pagos studies in his mysterious library

JOHN ROWE

Address
c/o Michael Neugebauer Verlag
Industriestrasse 837
CH-8625 Gossau / Zürich
(Switzerland)

Place and date of birth
Guilford,
5 August 1949

Art Schools attended
Richmond Art School, London
Epson School of Art and Design, Surrey
Twickenham College of Technology, Surrey
Insitute of Applied Arts, Vienna

Works published by
Michael Neugebauer Verlag, Zurich / Salzburg

Title of the work
Baby Crowe

Original Publisher and date of publication
Michael Neugebauer Verlag, Zurich / Salzburg, 1994

Technique
Acrylic

Legend
Crows in the tree

Baby crowe

MARIE JOSÉ SACRÉ

Address
c/o Bohem Press
Gerechtigkeitsgasse 31
8002 Zürich
(Switzerland)

Place and date of birth
Battice,
1946

Art School attended
Academy of Fine Arts, Liege

Works published by
Bohem Press, Zurich
Edizioni Arka, Milan
Editions Epigones, Paris
Dempa Publications, Tokyo
Uitgeverij de Vries, Antwerp
Lasten Keskus Dy, Helsinky

Title of the work
The Tiny Hare and the Fox

Original Publisher and date of publication
Bohem Press,
Zurich, 1994

Technique
Gouache

Legend
Bedtime

Home alone

MIRIAM SAGASTI

Address
502 Alabama Dr.
22070 Herndon VA
(USA)

Place and date of birth
Lima,
30 November 1948

Art Schools attended
School of Interior Design, Lima
N. Virginia Community College,
USA

Works published by
Barron's Educational Series Inc,
Hauppauge
Scholastic Cartwheel, New York
Newbridge Educational, New
York

Title of the work
From January to December

Technique
Coloured Pencil

Legend
February is snow sleding we go

August hot and sweet: juicy fruit to eat

School we must remember as leaves turn in September

November starts the cold; the year is getting old

RETI SAKS

Address
Rataskaevu 12
EE 0001 Tallinn
(Estonia)

Place and date of birth
Pärnu,
3 June 1960

Art Schools attended
Art Institute of Tallinn, Estonia

Works published by
Eesti Raamat, Tallinn

Title of the work
The Soul Bird

Original Publisher and date of publication
Aviv ltd.,
Tallinn, 1992

Technique
Watercolour

Legend
The soul bird is made of several drawers which only it can open

BEATE SPECK KAFKOULAS

Address
Pfarrer Grimm Strasse 42
D-80999 München
(Germany)

Place and date of birth
Munich,
6 September 1953

Art Schools attended
Art Academy, Munich

Works published by
Ravensburger Buchverlag Otto
Maier GmbH, Ravensburg
K. Thienemanns Verlag,
Stuttgart

Title of the work
Zaid and Luithar

Technique
Mixed

Legend
In the hide-out

Vultures in the sky

Homesickness

DON SULLIVAN

Address
912 So. Telluride Street
80017 Aurora CO
(USA)

Place and date of birth
Des Moines, Iowa,
20 December 1953

Works published by
Newport Publishers,
Laguana Nigeal, 1992

Title of the work
Animals at Night

Original Publisher and date of publication
Newport Publishers,
Laguana Nigeal, 1992

Technique
Marker and coloured pencil

Legend
Sleep tight

Friends on the prowl

Winner of the 94 Illustrators
of the Year Award
UNICEF / Bologna Book Fair

150

MÁRTON TAKÁTS

Address
Szölö 45
2097 Pilisboroszenö
(Hungary)

Place and date of birth
Budapest,
22 June 1971

Art School attended
Hungarian Academy of Fine Arts

Title of the work
The Lord of the Rings

Technique
Etching

Legend
At the gate of Gondor: the meeting of the black and white riders

Balin's tomb: Gandalf and his group find the tomb of the famous king Balin

JUTTA TIMM

Address
Schemmannstrasse 10
D 22359 Hamburg
(Germany)

Place and date of birth
Cuxhaven,
2 September 1945

Art School attended
Private School of Fine Art,
Karsruhe

Works published by
Ellermann Heinrich KG Verlag,
Munich
Verlag Friedrich Oetinger,
Hamburg
Nord-Süd Verlag AG, Gossau /
Zurich
Ravensburger Buchverlag Otto
Maier GmbH, Ravensburg
Loewes Verlag, Bindlach
Franz Schneider Verlag, Munich
Rowohlt Taschenbuch Verlag,
Reinbek

Title of the work
The Noisemaker's House

Original Publisher and date of publication
Ellermann Heinrich KG Verlag,
Munich

Technique
Watercolour and coloured pencil

Legend
Debbie Diddle
in the middle
throws with seven bowls
to a rock and roll

Just the quiets
hate the riot
and they steal away
on that very day

WINNER OF THE 94 ILLUSTRATORS
OF THE YEAR AWARD
UNICEF / BOLOGNA BOOK FAIR

MARIT TÖRNQVIST

Address
Van Oldenbarnevelotstraat 18 II
1052 KA Amsterdam
(The Netherlands)

Place and date of birth
19 January 1964

Art School attended
Gerrit Rietveld Academie,
Amsterdam

Works published by
AB Rabén & Sjögren Bokforlag,
Stockholm
De Boekerij BV, Amsterdam
Em. Qurido's Uitgeverij B.V.,
Amsterdam
Lemniscaat B.V., Rotterdam
UNICEF, Geneva
Gyldendal, Copenhagen
N.W Damm & Son A.S., Oslo
Werner Söderström Osakeyhtö,
Helsinki
Forlagen Sesam A/S,
Copenhagen
Verlag Friedrich Oetinger,
Hamburg
R&S Books, New York

Title of the work
The Old Musician Picturebook

Original Publisher and date of publication
AB Rabén & Sjögren Bokforlag,
Stockholm

Technique
Watercolour

Legend
The girl and the musician

The windowpalace

MONIA TRENTINI

Address
Via Del Greto 4/3
40132 Bologna
(Italy)

Place and date of birth
Bologna,
22 July 1974

Art School attended
Art College

Title of the work
The Little Matchstick Seller

Technique
Watercolour

Legend
....... she took the child in her arms and together they flew up to God

....... what a strange light! She felt she was sitting in front of a great fire

CLARA URQUIJO

Address
Gurtenstrasse 50
3122 Kehrsatz Bern
(Switzerland)

Place and date of birth
Buenos Aires,
7 October 1949

Art Schools attended
National School of Fine Arts,
Buenos Aires
Croydon College of Art, London

Works published by
Atlantida S.A. Editorial, Buenos Aires
Ediciones de Arte Gaglianone, Buenos Aires
Editorial Abril, Buenos Aires
Editorial El Ateneo, Buenos Aires
Editorial Lumen S.A., Barcelona

Title of the work
Mirasol

Technique
Ink line, coloured ink and black pencil

Legend
Magoe and Magora came with the twin brothers Canela and Canelo on this birthday morning

Cover

MIRASOL

ROSARIO VALDERRAMA

Address
Prado Sur 770
Lomas de Chapultpec
11000 Mexico City
(Mexico)

Place and date of birth
3 January 1958

Art Schools attended
Metropolitan University

Works published by
Fernandez Editores S.A., Mexico D.F.
Editorial Vicens Vives, Barcelona
Ravensburger Buchverlag Otto Maier GmbH, Ravensburg
Macmillan / MacGraw-Hill International, New York
Silver Burdett Press, Englewood Cliffs
Editorial Trillas S.A. de C.V., Mexico D.F.
Conafe, Mexico D.F.
Cidcli, Mexico D.F.
Corunda, Mexico D.F.

Title of the work
The Life of "Lazarillo de Tormes"

Original Publisher and date of publication
Editorial Vicens Vives, Barcelona

Technique
Pencil

Legend
The coffer of bread

The unfaithful wife

Questions at dinner-time

CLAUDIA VENTURINI

Address
Via Scandiana 17
44100 Ferrara
(Italy)

Place and date of birth
Ferrara,
3 January 1962

Title of the work
The Three Piglets

Technique
Mixed

Legend
"We'll build them up there"

"Mmm...... piglet smell"

"...... help!"

CHIA-CHU WANG

Address
12 F, 447 Jen-Ai Rd., Sec. 4
Taipei, Taiwan
(China)

Place and date of birth
Peng-Hu,
21 April 1964

Art Schools attended
Ming Chuan College

Works published by
Grimm Press, Taipei

Title of the work
Candy House

Original Publisher and date of publication
Grimm Press,
Taipei, January 1994

Technique
Mixed

Legend
The witch pretended to be a teacher

The witch is watching on the roof

166

ULISES WENSELL

Address
Porto Colon 12
28924 Alarcon Madrid
(Spain)

Place and date of birth
Madrid,
20 October 1945

Works published by
Ravensburger Buchverlag Otto
Maier GmbH, Ravensburg
Bayard Presse, Paris

Title of the work
They Followed a Bright Star

Original Publisher and date of publication
Ravensburger Buchverlag Otto
Maier GmbH,
Ravensburg, 1993

Technique
Mixed

Legend
The shepherds

The wise men trace the path of the star

WINNER OF THE 94 ILLUSTRATORS OF THE YEAR AWARD
UNICEF / BOLOGNA BOOK FAIR

JOZÉF WILKOŃ

Address
c/o Bohem Press
Gerechtigkeitsgasse 31
8002 Zürich
(Switzerland)

Place and date of birth
Bogucice,
1930

Art Schools attended
Art Academy, Krakow
University, Krakow

Works published by
Bohem Press, Zurich
Edizioni Arka, Milan
Nord-Süd Verlag AG, Gossau / Zurich
Editions Epigones, Paris
Lasten Keskus, Helsinki
Lelmniscaat B.V., Rotterdam
Hutchinson, London
Patmos Verlag, Düsseldorf
Sailor Publishing Co. Ltd., Tokyo
Schuppan News Co. Ltd., Tokyo

Title of the work
Little Wolves

Original Publisher and date of publication
Bohem Press,
Zurich, 1993

Technique
Mixed

Legend
Running home

The little wolf and the mouse

LUDMILA ZEMAN

Address
180 Herbert, St.Laurent
H4N 2K5 Québec
(Canada)

Place and date of birth
Zlin,
23 April 1947

Art School attended
School of Applied Arts, Uh. Hradiste

Works published by
Tundra Books, Montréal

Title of the work
The Epic of Gilgamesh the King

LISBETH ZWERGER

Address
c/o Michael Neugebauer Verlag
Industriestrasse 837
CH-8625 Gossau/ Zürich
(Switzerland)

Place and date of birth
Vienna,
26 May 1954

Art School attended
College of Applied Arts

Works published by
Michael Neugebauer Verlag,
Zurich / Salzburg
C'era una volta......di A. Stoppa
& C., Pordenone
Ravensburger Buchverlag Otto
Maier GmbH, Ravensburg
Editions Duculot,
Louvain-La-Neuve
Ediciones Destino, Barcelona
Kaisei-Sha Publishing Company
Ltd., Tokyo
MP, The Netherlands
You Moon Dang, Korea

Title of the work
Dwarf-Nose

Original Publisher and date of publication
Michael Neugebauer Verlag,
Gossau / Zurich

Legend
Dwarf-Nose in the garden

Dwarf-Nose on the sofa

Copyright © 1994
Fiera del Libro per Ragazzi
Piazza Costituzione 6
40128 Bologna, Italy

Distributed in **Italy only**, by
Bologna Fiere
Piazza Costituzione 6
40128 Bologna, Italy

Logos Impex s.r.l.
Via Curtarona, 5/F
41010 S. Darnaso,
Modena, Italy
Tel. (059) 28 02 64
Fax. (059) 28 16 87
Tlx. 522271 LOGOS I

Copublished with and
distributed by:

Michael Neugebauer Verlag AG
Industriestrasse 837
CH-8625 Gossau Zürich
Tel. (1) 936 17 17
Fax (1) 936 17 00

Germany and Austria:
Michael Neugebauer Verlag AG
c/o Vertriebsbüro Hamburg
Poppenbütteler Chaussee 53
D-22397 Hamburg
Tel. (40) 607 909 06
Fax (40) 607 23 26

France:
Editions Nord-Sud
c/o SOFEDIS
29, rue Saint-Sulpice
F-75006 Paris
Tel. (143) 29 09 60
Fax (146) 33 71 59

Canada
Editions Nord-Sud
c/o Diffusion Dimedia Inc.
539, Lebeau blvd
Ville St-Laurent, Québec
H4N 1S2
Canada
Tel. (514) 336 39 41
Fax (514) 331 39 16

USA
North-South Books Inc.
1123 Broadway, Suite 800
New York, N.Y. 10010
USA
Tel. (212) 463 97 36
Fax (212) 633 10 04

Canada
North-South Books
c/o Vanwell Publishing Ltd.
1, Northrup Crescent
St. Catharines
Ontario L2M 6P5
Canada
Tel. (905) 937 31 00
Fax (905) 937 17 60

Great Britain
North-South Books
c/o Ragged Bears Ltd.
Ragged Appleshaw
Andover
GB-Hampshire SP11 9HX
Tel. (264) 772 269
Fax (262) 772 391

Japan
North-South Books Japan
Enshu Bldg. 3-3, Otsuka 3-Chome
Bunkyo-ku
Tokyo 112
Japan
Tel. (3) 3942 3986
Fax (3) 3942 1523

Australia
North-South Books
c/o CIS Educational Pty. Ltd.
245 Cardigan Street
Carlton, Victoria 3053
Australia
Tel. (3) 349 1211
Fax (3) 347 0175

Netherlands
De Vier Windstreken
Industrieweg 7
NL-2254 AE Voorschoten
Tel. (71) 617 642
Fax (71) 619 741

Taipei
Michael Neugebauer Verlag
c/o Tang Yung Co, Ltd.
8F-2, No 291 Sec. 2,
Fu Hsing South Road
Taipei
Tel. (2) 7089092
Fax (2) 7031642

Graphic Designer:
G. Lanzi/Bologna
Lithographed films:
Fotolito FD s.r.l./Bologna
Printer:
Grafiche Zanini - Bologna

Per informazioni:
For information:

BolognaFiere

Mostra degli Illustratori
Piazza Costituzione 6
40128 Bologna (Italy)
Tel.: 051 - 282111
Telex: 511248 FIERBO I
Telefax: 051 - 282332

L'Ente Fiera declina
ogni responsabilità per
eventuali omissioni,
errate indicazioni e
descrizioni, incertezze,
errori di stampa relativi
ai nomi e ai dati degli
illustratori.

*The Fair Organization
assumes no
responsibility for any
omission, incorrect
information and
description, oversight
or printing error in
respect of the
illustrators' names and
curricula.*

All rights reserved
Printed in Italy
ISBN 0-88708-311-0

29ª Mostra degli
Illustratori
Sezione Fiction
6-9 Aprile
Chiusura iscrizioni
15 Novembre 1994

*29th Illustrators
Exhibition*
Fiction Section
April 6-9
*Deadline for entries
is November 15th 1994*

Richiedete il **NUOVO**
regolamento di
partecipazione a:
*For the **NEW** rules of
entry please contact:*

Mostra Illustratori
Bolognafiere
Piazza Costituzione 6
40128 Bologna